FEEL IT OUT

THE GUIDE TO GETTING IN
TOUCH WITH YOUR GOALS,
YOUR RELATIONSHIPS,
AND YOURSELF

JORDAN SONDLER

HARPER
DESIGN
An Imprint of HarperCollinsPublishers

Published in 2020 by
Harper Design
An Imprint of HarperCollins Publishers
195 Broadway
New York, NY 10007
Tel: (212) 207-7000
Fax: (855) 746-6023
harperdesign@harpercollins.com
www.hc.com

Distributed throughout the world by
HarperCollins Publishers
195 Broadway
New York, NY 10007

ISBN 978-0-06-293875-6
Library of Congress Control Number:
2019937748

Design by Nancy Leonard

Printed in China

First Printing, 2020

Sondler Sans typeface created by
Spencer Charles, Douglas Hayes,
and Flavia Zimbardi

this book is
dedicated to
fifteen years
of therapy

COULDN'T HAVE DONE IT
WITHOUT YOU BABY ♥♥

CONTENTS

INTRODUCTION

A FEW YEARS AGO, I found myself at a crossroads. I had spent five years living with a partner, and only after finding myself single for the first time in my young adult life did I realize that I didn't really know myself. Sure, I knew myself as part of a couple, but at the end of the day, alone in my thoughts, I was overwhelmed with confusion—what were my preferences, what kind of people did I want to surround myself with, what were my goals, alone? This came as a surprise to me; I had spent years launching a successful freelance career and cultivating a group of talented friends in New York City. How can someone be running swiftly toward their dreams while simultaneously feeling directionless? The answer is simple—for years I lost myself, my real self, in my relationship. I was more in touch with who I was and what made me happy when I was eighteen than I was at twenty-seven—a realization, and feeling, I never want to have again.

You and I have heard that "it's okay to be yourself" all our lives, but when you're in the throes of big life changes like this, the words usually feel empty. What do they even mean? The day that I start accepting myself for who I am (a chubby, moody, tattooed people-pleaser), will someone throw a party in my honor? Will the world lay down paychecks at my feet? There's always so much outside pressure to be happy, have it all, and have it all together at all times. Sometimes it's hard to separate who you are, intrinsically, from what your expectation of your life should be. Through the ups and downs of rediscovering myself, I learned that the goal is not to be happy all of the time, or to reach a certain measure of success in life before allowing myself

to feel satisfied with who I am. We don't have that kind of time to waste. Being a sometimes-happy, sometimes-confused, and sometimes-lonely person is perfectly okay. This doesn't necessarily mean that everyone else will understand or celebrate that version of me, but learning to embrace the most authentic version of myself is more important than changing who I am to get that validation from other people.

What I learned during this time of self-exploration is that there are a lot of us looking for a way back to our truest selves, especially when we find ourselves in that space between who we are and who we hoped we'd be. Not long ago, I was in a place where I felt I needed a guide for navigating this life shift but couldn't find one. Now, 140-plus pages later, here it is. I've filled these pages with personal experiences and lessons that unveil universal truths (talking to your pet most hours of the day is normal, right?). The resounding message here is to be kind to yourself and to know that you are capable of finding happiness within, regardless of what that means to you. Happiness may look like significantly different things to your mother, your dog, or your postman—at least that's what my therapist tells me. And that's cool because can you even imagine being married to your BFF's husband? While this book can't prescribe exactly what you are going to need on your personal path to self-discovery, I hope it will be an empathetic, vulnerable, utterly relatable companion and guide to anyone navigating the age-old and universal experiences of loneliness and joy and everything in between.

So pour yourself a drink and join the party. Let's figure out where you're at, how to make a change, how others come into play, and what steps you can take to live the most fulfilling and exciting life that you can!

CHAPTER 1

WHERE I'M AT & HOW TO LOVE MYSELF FOR IT

DEAR READER: ARE YOU HAPPY? I don't mean do you have everything you want in life, but are you generally pleased? No one is happy all of the time, and no one should be. Our bad days make the good so much shinier—how would you know what's right if you didn't know what was wrong?

It seems silly, but awareness about ourselves and our feelings can have such a big impact on our attitudes. Before we can grow and move forward, we need to make peace with where we are in our lives and figure out how to love ourselves for, not in spite of, it.

GOALS

WORK

WHERE
YOU

MENTAL
HEALTH

RELATIONSHIP

WHEREVER YOU GO,
THERE YOU ARE.

YOU CAN KEEP ON SEARCHING
FOR A NEW YOU, OR YOU COULD
LOVE YOURSELF NOW

JUST ONE MORE YEAR, ONE MORE PROJECT, ONE MORE KISS, AND THEN YOU'LL BE HAPPY

HOW TO BE PRESENT

IF YOU FIND YOURSELF DISTRACTED, PUT AWAY THE PHONE!! IT'S HARD TO FOCUS WHEN THERE IS A CUTE PUPPY PHOTO OR WORK E-MAIL AT YOUR FINGERTIPS.

WHEN YOU'RE A COOL, AMBITIOUS PERSON WITH YOUR WHOLE LIFE AHEAD OF YOU, IT'S HARD TO NOT ALWAYS THINK ABOUT THE UNKNOWN. TRY TO FOCUS ON WHAT'S HAPPENING RIGHT NOW. YOU'LL REGRET THE TIME YOU WASTE.

LISTENING TO MUSIC IS GREAT FOR MINDFULNESS.

& LIVE IN THE MOMENT

HOLD A ROCK IN YOUR HAND TO KEEP YOURSELF FOCUSED AND OCCUPIED DURING CONVERSATION. THIS IS ALSO GREAT FOR ANXIETY.

TAKE A BREAK, TAKE A WALK, TAKE A NAP. BREATHING IS IMPORTANT, AND SO IS GETTING OUT OF YOUR HEAD SPACE.

CHANGE YOUR MIND-SET. EVERY MOMENT CAN TEACH YOU SOMETHING, SO PAY ATTENTION.

MIDLIFE CRISIS

teenage years

LiFE

EXPRESSING GRATITUDE FOR WHERE I'M AT

THINGS TO BE GRATEFUL FOR

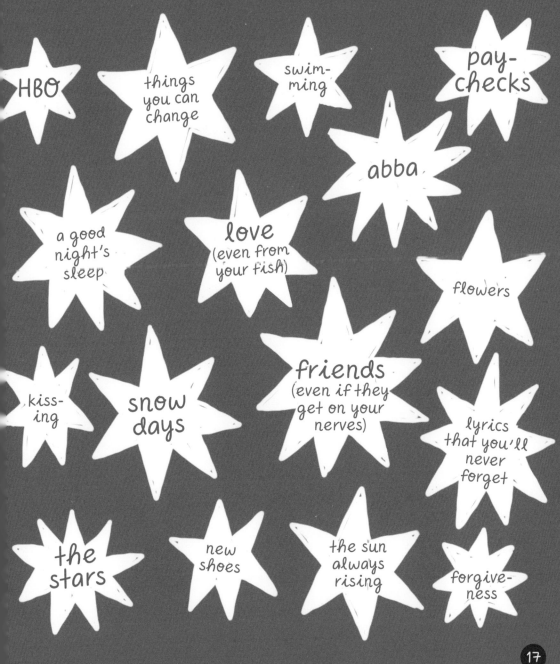

HBO

things you can change

swim-ming

pay-checks

abba

a good night's sleep

love (even from your fish)

flowers

kiss-ing

snow days

friends (even if they get on your nerves)

lyrics that you'll never forget

the stars

new shoes

the sun always rising

forgive-ness

HOW TO FEEL GOOD IN THE SKIN YOU'RE IN

- Buy pants that make you feel fabulous. It must be pants; they will make your butt look great and boost your confidence.

- Speaking of confidence, speak up more. Raise your hand in class, share your thoughts with your boss, correct that friend who spells your name wrong. You are smart and deserve to be heard.

- Say hi to your neighbors and smile at strangers. Something about these brief exchanges is so lovely.

- Interact with the people you admire on social media. You might even make a friend or two.

- Think about everything you've made happen for yourself in the past five years.

- Remember that we are all in transition, and you have the power to make things happen.

- Try to be more permissive and kind to yourself. Talk to yourself like a friend would!

- Use lip scrub. (Life-changing.)

REFRAMING THINGS IF

SOMETIMES A CHANGE IN PERSPECTIVE CAN REALLY FEEL LIKE MAGIC. I MIGHT FEEL INITIAL ANGER AT A CLIENT WHO QUESTIONS MY JUDGMENT. BUT IF I SIT AND THINK ON IT, I CAN THINK OF MANY GREAT THINGS THAT STEMMED FROM COLLABORATION.

HUMOR ALWAYS HELPS. NORA EPHRON SAID, "EVERYTHING IS COPY," AND IT'S TRUE. THINK OF ALL THE GREAT THINGS THAT WERE BORN OUT OF PERSONAL EXPERIENCE.

TRY MAKING A LIST—PHYSICAL OR MENTAL—OF ANY POSITIVES REGARDING THE SITUATION.

YOU CAN'T CHANGE THINGS

ASK YOURSELF, IS THIS REALLY SO BAD? OR AM I JUST ANXIOUS ABOUT THE CIRCUMSTANCES BECAUSE IT'S NOT WHAT I EXPECTED?

DELETE Y/N

YOUR INNER NEGATIVE CRITIC IS ONLY TRYING TO HELP YOU. TRY TO REALLY LISTEN AND PICK UP ON THESE THOUGHTS SO THAT YOU CAN THROW THEM AWAY AND REPLACE THEM WITH NEW ONES.

THINK: WHAT CAN I LEARN FROM THIS? WHAT CAN I DO TO MAKE PEACE WITH THIS? START USING NICER WORDS AND TALKING TO YOURSELF LIKE A BFF.

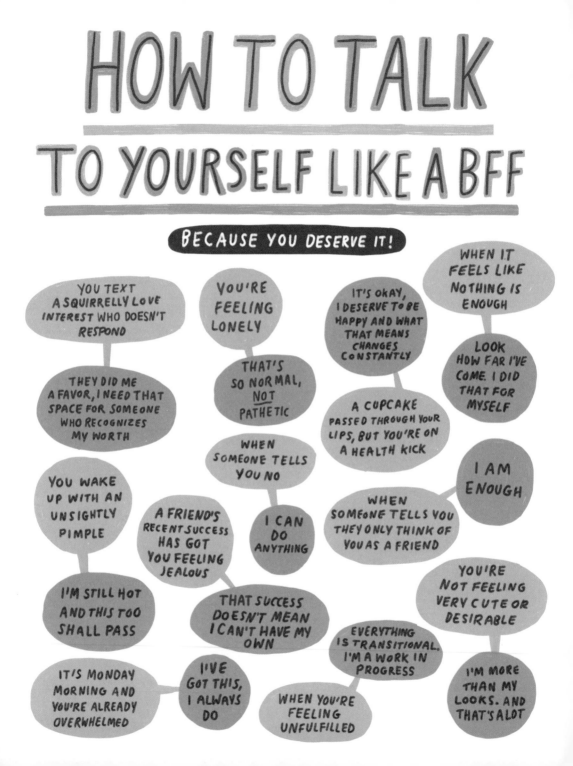

I'M SO AMAZING

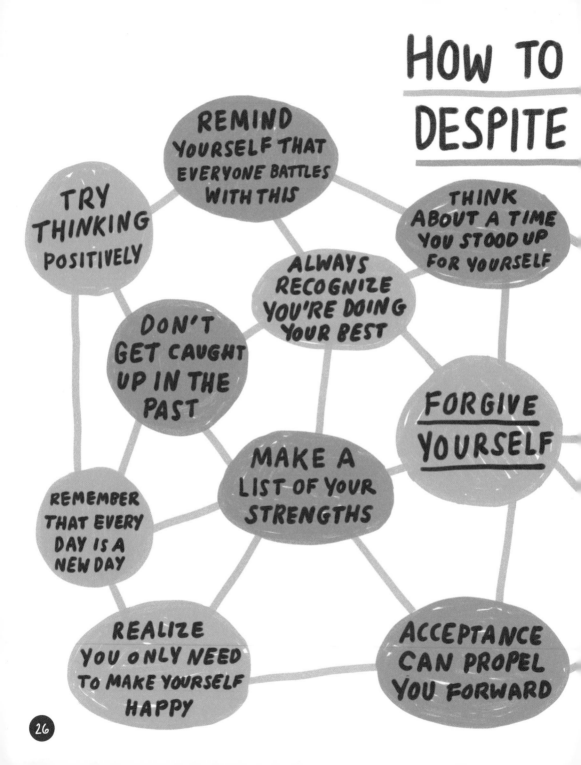

ACCEPT YOURSELF
FLAWS

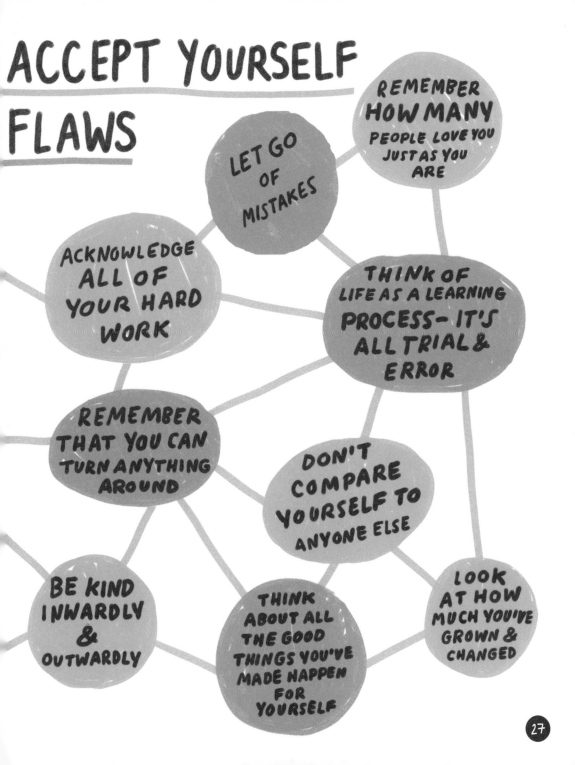

LET GO OF MISTAKES

REMEMBER HOW MANY PEOPLE LOVE YOU JUST AS YOU ARE

ACKNOWLEDGE ALL OF YOUR HARD WORK

THINK OF LIFE AS A LEARNING PROCESS— IT'S ALL TRIAL & ERROR

REMEMBER THAT YOU CAN TURN ANYTHING AROUND

DON'T COMPARE YOURSELF TO ANYONE ELSE

BE KIND INWARDLY & OUTWARDLY

THINK ABOUT ALL THE GOOD THINGS YOU'VE MADE HAPPEN FOR YOURSELF

LOOK AT HOW MUCH YOU'VE GROWN & CHANGED

NO ONE'S SUCCESS HAS ANY BEARING ON YOUR OWN

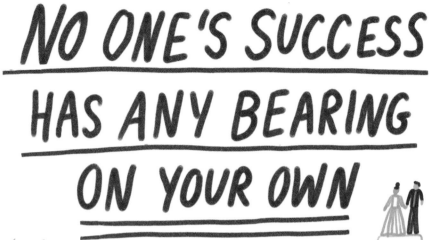

NO ONE KNOWS WHAT THE FUTURE HOLDS; JUST BECAUSE SOMETHING HAPPENED FOR A FRIEND, DOESN'T MEAN IT WON'T HAPPEN FOR YOU

WE'RE ALL ON SUCH DIFFERENT PATHS. WHO KNOWS WHERE YOU'RE HEADED?

ONCE YOU ACCEPT THIS, WEDDINGS BECOME A LOT MORE FUN

INBOX (1)

YOUR FRIEND JUST RECEIVED A LIFE-CHANGING E-MAIL? COOL, YOURS MIGHT COME TOMORROW

GO TEAM

LET THEIR SUCCESS INSPIRE YOU. CHEER ON THE PEOPLE YOU LOVE AND ADMIRE

EVERYTHING WILL EVENTUALLY COME UP ROSES

HOW TO NOT BE BUMMED

IF YOU FIND YOUR-
SELF SCROLLING FOR
HOURS ON INSTAGRAM,
AND YOUR DAY AT
HOME IN PAJAMAS
HAS YOU DREAMING
ABOUT TAHITI, YOU'RE
NOT ALONE.

IT'S EASY TO FORGET THAT
SOCIAL MEDIA IS ALL SMOKE
AND MIRRORS. JUST REMIND
YOURSELF THAT YOUR INSTA-
CRUSH WILL BE AT THE DMV
TOMORROW OR IS FREAKING
OUT OVER THEIR TAXES.

WHEN YOU FIND YOUR-
SELF OBSESSING, SWITCH
OVER TO YOUR FAVORITE
PET CELEBRITY'S
ACCOUNT. ANIMALS
ALWAYS KNOW JUST THE
RIGHT THING TO SAY.

OUT BY THE INTERNET

THERE'S NO SHAME IN TAKING A BREAK FROM SOCIAL MEDIA TO CLEAR YOUR HEAD. YOU COULD JUST, YOU KNOW, LIVE YOUR LIFE LIKE NO ONE'S WATCHING.

DELETE FACEBOOK?

CANCEL | DELETE

JDS

MAKE A POINT TO FOLLOW POSITIVE ACCOUNTS THAT INSPIRE YOU & PUMP YOU UP. THERE ARE SO MANY AMAZING, REAL & HONEST PEOPLE ON THE INTERNET THESE DAYS.

THERE IS ABSOLUTELY NO SHAME IN UNFOLLOWING SOMEONE. SET YOURSELF FREE FROM NEGATIVE THOUGHTS. NO ONE CAN BLAME YOU FOR LOOKING OUT FOR YOU.

GOODBYE

GOODBYE

GOODBYE

WE'RE ALL UNIQUE AND INTERESTING because of our differences. Sometimes it feels isolating to have interests—or disinterests—that conflict with a friend's taste. But being true to yourself is far more important and freeing than *fitting in*. Don't discount what you like just because it might be seen as dorky. If I did that, I wouldn't have some of my favorite records because an ex thought my choices were lame. Allow yourself to do the things you love just because you love them. That's enough.

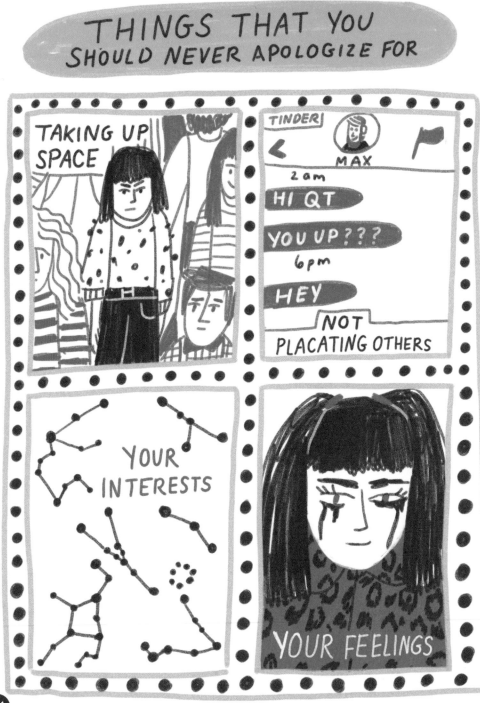

ROLLING OUT INTO THE CROSSWALK

TAKING THE LAST SELTZER WITHOUT REPLENISHING

HOPPING INTO THE SHOWER AT THE SAME TIME AS YOUR ROOMMATE

JORDAN UNFOLLOWED YOU!! WTF!

HURTING SOMEONE'S FEELINGS

AT THE END OF THE DAY, you are the only person that you need to worry about pleasing. If there is something that you need to do to feel better, don't give it a second thought. Staying home to catch up on *The Real Housewives* is sometimes more important than going out dancing with friends. If you need to text your crush to get things off of your chest, don't hesitate. We are all only human—be yourself unapologetically.

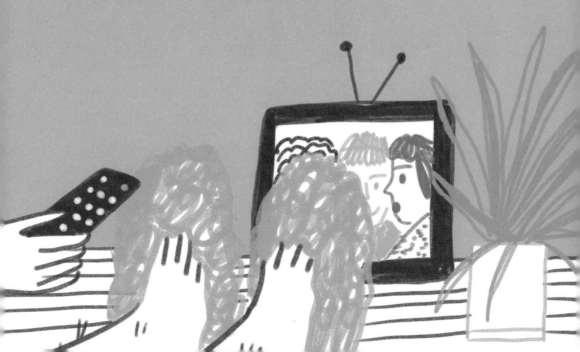

GOING AT MY OWN SPEED

AS ANNOYING AS IT SOUNDS, it's truly about the process. Maybe you thought you'd be on a different schedule in life, but does that really matter? There's still time to have everything that you want—and more. Maybe you didn't even know what you wanted. Maybe you wanted what someone else wanted. Maybe you're still figuring out what you want, and that's just fine.

CHAPTER 2
HOW TO MAKE A CHANGE

NOW THAT WE'VE FIGURED OUT what we're working with, we can begin to make changes. Learning to listen to your own needs over your busy social calendar is so important. All of your friends will still be hanging out tomorrow—tonight we're going to wash that sink full of dishes, light a candle that smells like licorice, break open a notebook, and talk about our feelings.

HEALTHY HABITS

USE ALL OF YOUR VACATION DAYS. AND IF YOU'RE SELF-EMPLOYED, CREATE THEM.

MARCH

X	X	X	X	X	X	X
X	X	V	A	C	A	T
I	O	N	!!!	!!		

MAKE TIME TO DO THE THINGS YOU LOVE. IF YOU DON'T EVEN KNOW WHAT THOSE ARE, SPEND TIME DISCOVERING THEM.

8 HOURS OF SLEEP IS IMPORTANT. TAKE A NIGHT OFF TO CRAWL INTO BED EARLY WITH YOUR PET.

FOR SELF-CARE

EAT THE THINGS YOU LOVE — AND BETTER YET, COOK THEM!! TAKE A TRIP TO THE FARMERS MARKET TO PICK UP ALL YOUR FAVORITES.

RUN, JOG, WALK, OR CRAWL OUTSIDE. ENJOYING YOUR SURROUNDINGS AND LOOKING UP AT THE TREES IS CATHARTIC.

PENCIL IN SOME ALONE TIME EVERY WEEK. EVEN A LONG SHOWER & A PODCAST CAN DO THE TRICK.

CONDITIONER

BUBBLE

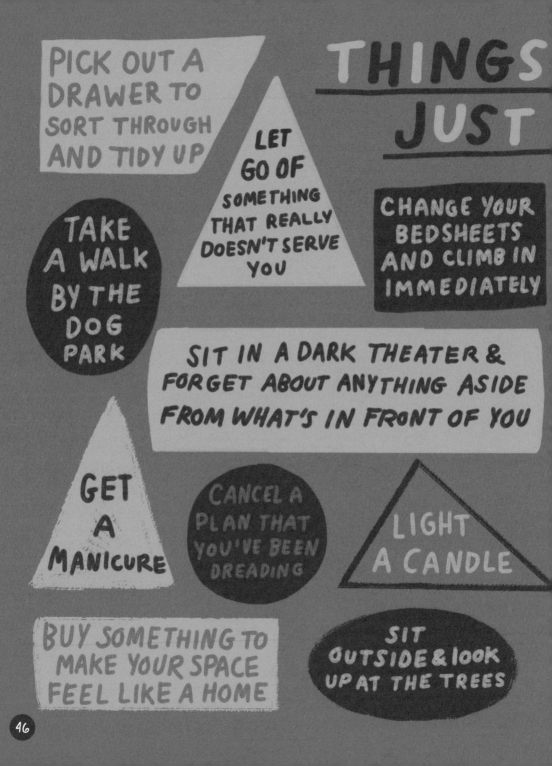

PICK OUT A DRAWER TO SORT THROUGH AND TIDY UP

THINGS JUST

LET GO OF SOMETHING THAT REALLY DOESN'T SERVE YOU

TAKE A WALK BY THE DOG PARK

CHANGE YOUR BEDSHEETS AND CLIMB IN IMMEDIATELY

SIT IN A DARK THEATER & FORGET ABOUT ANYTHING ASIDE FROM WHAT'S IN FRONT OF YOU

GET A MANICURE

CANCEL A PLAN THAT YOU'VE BEEN DREADING

LIGHT A CANDLE

BUY SOMETHING TO MAKE YOUR SPACE FEEL LIKE A HOME

SIT OUTSIDE & look UP AT THE TREES

TO DO FOR YOU

TRY A NEW RECIPE

POUR YOURSELF YOUR FAVORITE DRINK

TAKE A SHOWER WITHOUT ANY DISTRACTIONS. FEEL THE WATER & BE PRESENT

FINALLY START WRITING IN THAT NEW DIARY

MAKE A PLAYLIST THAT IS EQUAL PARTS INSPIRING & COMFORTING

STOP BEATING YOURSELF UP

SKETCH, KNIT, SCULPT, PAINT, OR MAKE SOMETHING

WHEN ASKED TO COMMIT TO SOMETHING, ASK YOURSELF "DOES THIS SUIT ME?"

SIT DOWN WITH A BOOK

THE JOY OF
MISSING OUT

DO YOU LIKE TO DO THINGS BY YOURSELF? Aside from taking walks or a spin class, I can't remember doing many things on my own in the past. I first dipped my toe in the independent-activity waters by going to the movies. I've always liked going to the theater once or twice a year, but I started making a point of taking myself once a week— not looking at my phone once the lights dimmed, and not inviting anyone to share my popcorn. Why does one need to see a movie with someone else? You shouldn't be talking—that is a holy place to some (me)—and the sexual tension of being on a date distracts from any plot. What I'm trying to say here is that getting used to spending time alone, and subsequently liking it, is the key that unlocks JOMO, or "the joy of missing out." Think about it; if you value the time that you spend on yourself, you'll feel less frantic and less dependent. You'll even start to feel a sense of pride. And all the plans, all the friends, all the cocktails—they'll be there tomorrow.

feeling feelings is hard,
so here are some tips:

Ask yourself: "What am I feeling?" Consider that this uncomfortable emotion may be your body trying to tell you something.

Now, try to figure out WHY you are feeling this way. Keep digging because there's usually more under the surface.

However irrational or unjustified you might think your emotions are, that's irrelevant. Your feelings are real.

Sit with this feeling, no matter how painful. It won't last, and the longer you avoid it, the longer it lingers.

STOP being so hard on yourself. Think of this feeling objectively, as if a friend was confiding in you.

Things get worse before they get better. You're rearranging the furniture of your mind, and it's going to look better than ever!

YOU SHOULD BE STUDIED

NO, BUT ACTUALLY...

HERE ARE SOME TIPS REGARDING THERAPY:

- You can talk to a therapist about anything—your mom, your crush, how your dog is your best friend, the color green, or your sadness.

- Sometimes a particular professional isn't the right fit for you. That's absolutely okay. The right person is out there; don't give up!

- Discovering things about yourself can be really fun, but sometimes it's scary. Knowledge is power, friend.

- A lot of people don't understand therapy, but we're not going to let them stop us from feeling better.

- Stick with it! Much like starting a gym routine, this can feel like an uphill battle at first. It will be worth it.

- Therapy can actually get you out of your own head; doesn't that sound nice?

- If you seek out help, you are not crazy. It shows that you are smart and you love yourself.

THE BENEFITS OF A GOOD CRY

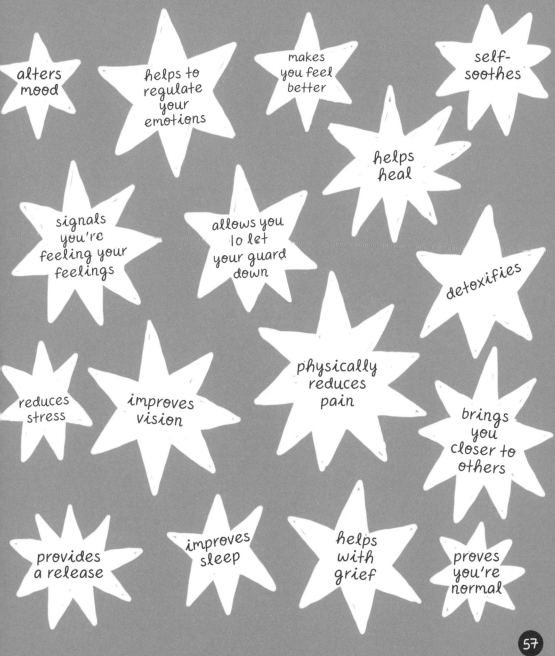

alters mood

helps to regulate your emotions

makes you feel better

self-soothes

helps heal

signals you're feeling your feelings

allows you to let your guard down

detoxifies

reduces stress

improves vision

physically reduces pain

brings you closer to others

provides a release

improves sleep

helps with grief

proves you're normal

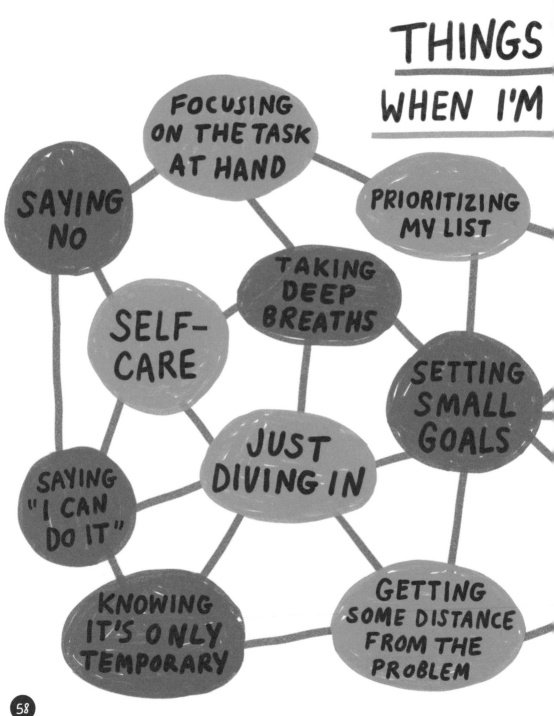

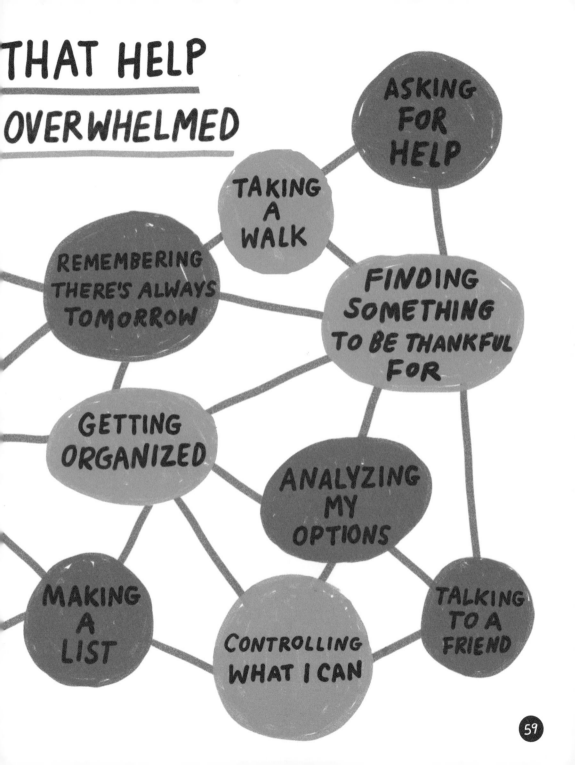

THAT HELP

OVERWHELMED

ASKING FOR HELP

TAKING A WALK

REMEMBERING THERE'S ALWAYS TOMORROW

FINDING SOMETHING TO BE THANKFUL FOR

GETTING ORGANIZED

ANALYZING MY OPTIONS

MAKING A LIST

CONTROLLING WHAT I CAN

TALKING TO A FRIEND

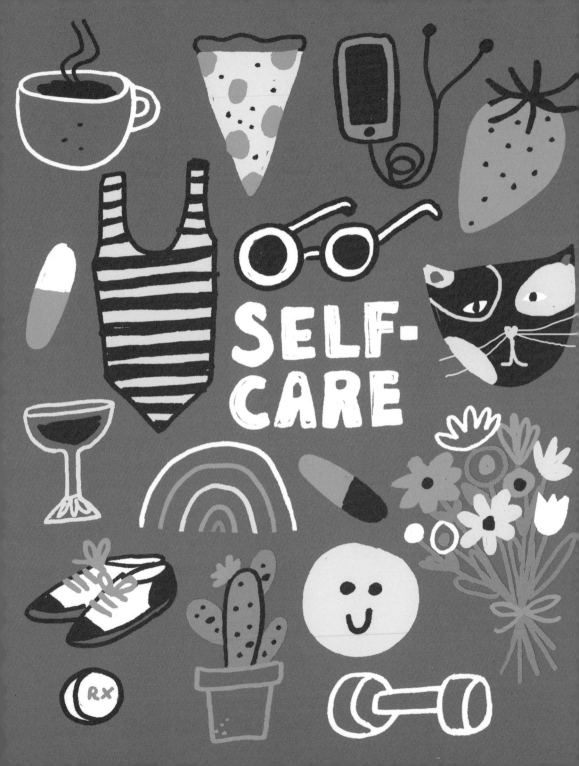

TEN THINGS WE CAN ALL DO RIGHT NOW
TO FEEL BETTER

1. Begrudgingly go for a run and realize halfway through that you can't stop smiling. You don't need to give your therapist the satisfaction of knowing they were right—they already know.

2. Eat a slice of pizza the size of your head. (Bonus good vibes if there's pepperoni on top.)

3. Go see any movie by yourself. (Movies can be substituted with any solo activity, like walking through a museum.)

4. Read your horoscope online. There's got to be *some* positivity in there.

5. Buy yourself a coffee/iced tea/glass of rosé and read a book.

6. Call a long-distance friend that you think about often but talk to infrequently.

7. Wear something you've been saving for the perfect occasion.

8. Start something that you've been putting off. Open that pile of mail, e-mail the frustrating client, call it quits with your on-again/off-again lover. The only way is forward.

9. Say goodbye to something that makes you feel mad, sad, or bad. It's not serving you, and we've got no time for that!

10. Hug an animal.

YOU DON'T HAVE TO BE HAPPY ALL THE TIME

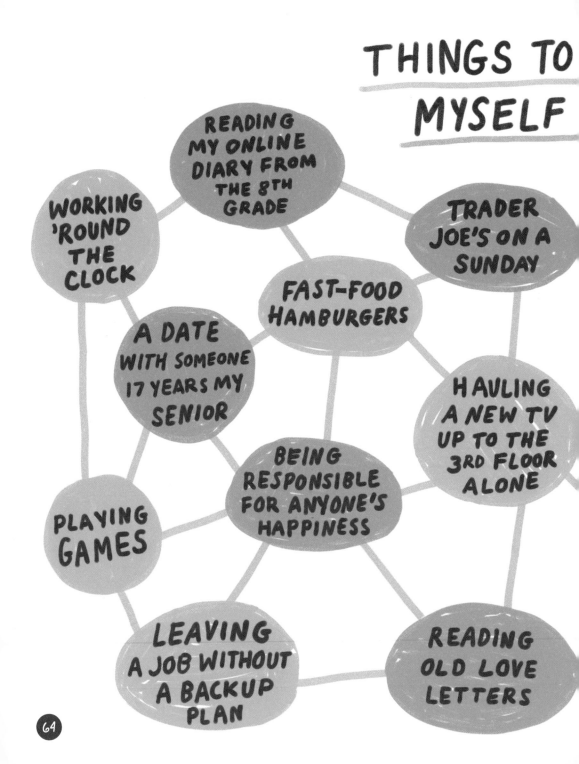

THINGS TO MYSELF

READING MY ONLINE DIARY FROM THE 8TH GRADE

WORKING 'ROUND THE CLOCK

TRADER JOE'S ON A SUNDAY

FAST-FOOD HAMBURGERS

A DATE WITH SOMEONE 17 YEARS MY SENIOR

HAULING A NEW TV UP TO THE 3RD FLOOR ALONE

BEING RESPONSIBLE FOR ANYONE'S HAPPINESS

PLAYING GAMES

LEAVING A JOB WITHOUT A BACKUP PLAN

READING OLD LOVE LETTERS

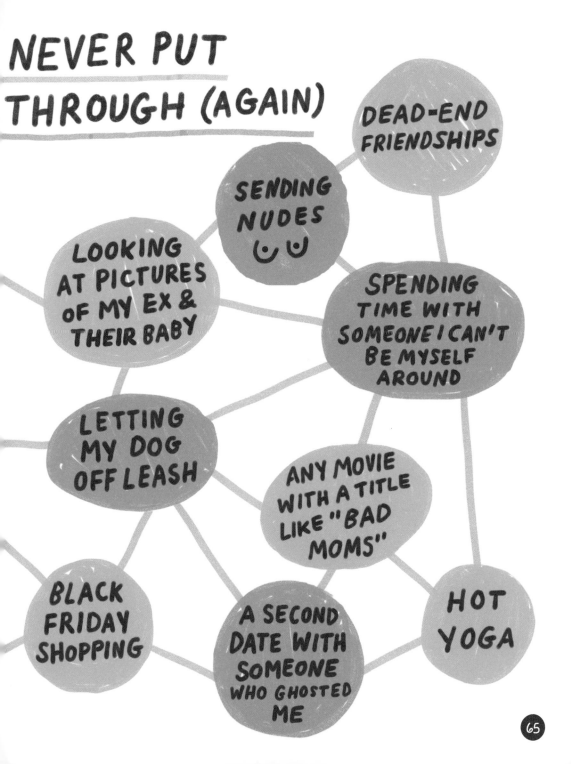

WHAT YOU ABSOLUTELY CAN CHANGE

YOUR ATTITUDE

WHAT YOU ACCEPT

YOUR HAIR

YOUR
FUTURE

WHO YOU SPEND
TIME WITH

YOUR PATTERNS

ARE YOU SENSING A THEME HERE?

WHAT YOU CANNOT EVER CHANGE

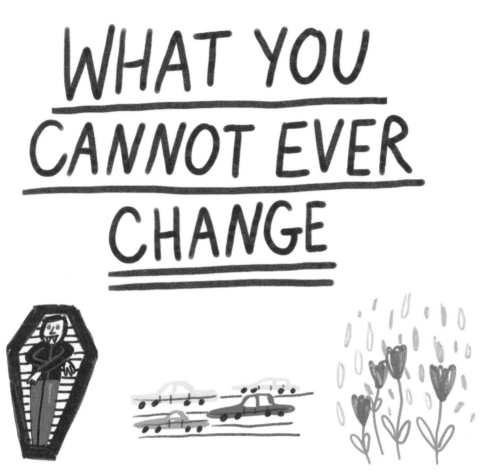

YOUR MORTALITY

TRAFFIC

THE WEATHER

WHAT YOU'VE LOST

YOUR PARTNER'S FLAWS

YOUR PAST

HOW TO START

PAY A VISIT TO YOUR TRUSTED HAIR STYLIST, OR BUY A FAKE PONYTAIL AND CHANNEL YOUR FAVORITE POP STAR.

BUY A PLANT. ANCHOR SOMETHING INTO YOUR WALL. THROW UP SOME WALLPAPER (BUT, LIKE, DOUBLE CHECK YOUR LEASE FIRST).

CHANGE YOUR DATING PROFILE TO THE LYRICS OF YOUR FAVORITE CELINE DION SONG.

JORDAN
ILLUSTRATOR
"BUT WHEN YOU TOUCH ME LIKE THIS, AND YOU

SHAKING THINGS UP

FINALLY START LOOKING FOR YOUR DREAM JOB.

CHALLENGE YOURSELF: LEARN A LANGUAGE, TAKE A CLASS, EAT NEW CHEESES.

STAY OUT LATE DANCING, ESPECIALLY TO '70s DISCO MUSIC AT A TIKI BAR.

CHAPTER 3
FIGURING OTHERS INTO MY LIFE

MAKING ROOM IN OUR LIVES FOR OTHER PEOPLE can be a tricky business, and you can only fully give yourself to someone else when you feel content with yourself first. Relationships (both romantic and platonic) are so important, but be mindful of not putting others' desires and needs before your own. Be careful not to use relationships as a Band-Aid or a distraction from dealing with your own issues. It's a fine line between putting yourself first and having compassion and respect for others' feelings.

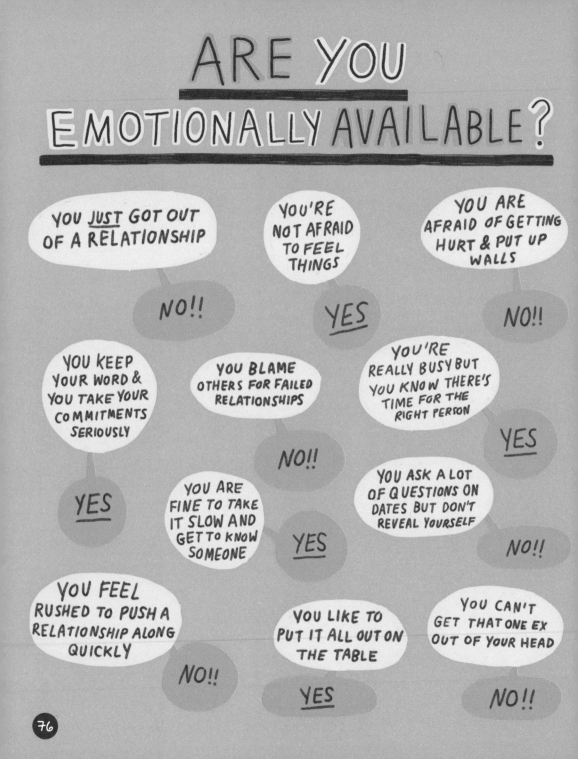

TIPS & TRICKS FOR GETTING OUT THERE

TAKE A SHOWER
BEFOREHAND TO
UNWIND

WEAR YOUR
FAVORITE THING

START WITH
A COMPLIMENT

REMEMBER: YOU NEVER
HAVE TO TALK TO
THESE PEOPLE AGAIN

KEEP AN OPEN MIND,
YOU NEVER KNOW
WHO YOU MIGHT MEET

YOU'RE DOING
THIS FOR YOU;
TRY TO HAVE FUN!

HOW TO PUT YOURSELF OUT THERE

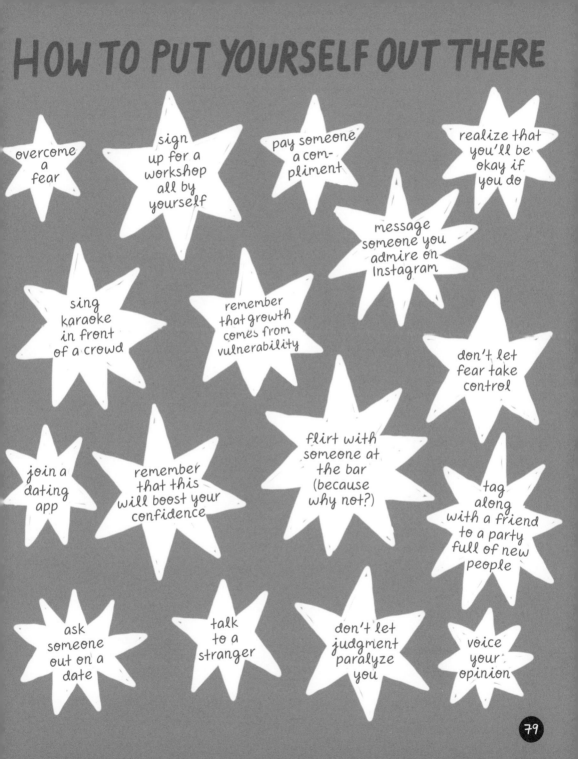

overcome a fear

sign up for a workshop all by yourself

pay someone a compliment

realize that you'll be okay if you do

message someone you admire on Instagram

sing karaoke in front of a crowd

remember that growth comes from vulnerability

don't let fear take control

join a dating app

remember that this will boost your confidence

flirt with someone at the bar (because why not?)

tag along with a friend to a party full of new people

ask someone out on a date

talk to a stranger

don't let judgment paralyze you

voice your opinion

how to be a good listener

Think about how good you feel when your friend is fully engaged in what you're saying, and reciprocate.

Clear your head and be present. Hold something in your hand if it helps you to focus.

Acknowledge that you're listening by giving thoughtful responses, but try not to interrupt.

Make eye contact to show you're engaged.

Ask questions from time to time; make suggestions if the conversation warrants it (and if your friend seems receptive).

Gaining trust, admiration, and even praise are some of the gratifying results of being a good listener. But most of all, you never know what you'll learn.

MAKING NEW FRIENDS AS AN ADULT

DON'T BE AFRAID
TO SLIDE INTO
SOMEONE'S DMS

REACH OUT TO A FRIEND
OF A FRIEND, SOMEONE
WHO ALWAYS SEEMS
FUN FROM AFAR

ORGANIZE A BOOK
CLUB, OR ANY CLUB
FOR THAT MATTER

TURN TINDER
MATCHES WITH NO
CHEMISTRY INTO
PLATONIC FRIENDSHIPS

TRY NEW THINGS;
MEET NEW FOLKS AT
POP-UP DINNERS,
WORKSHOPS, OR PARTIES

you're
invited
TO A
10 YEAR
Reunion

RECONNECT
WITH
OLD FRIENDS

THE ART OF FRIENDSHIP

WHEN I WAS SIX YEARS OLD, THE SPICE GIRLS TOLD ME THAT FRIENDSHIP NEVER ENDS. I SPENT THE NEXT TWO DECADES DISCOVERING THAT THIS IS JUST NOT TRUE. HERE ARE THE DIFFERENT TYPES OF FRIENDS—GOOD, BAD, AND UGLY.

THE CHILDHOOD FRIEND

You know the one—you would race home after school and instant message crushes together. You stole a bottle of champagne together from their mom's stash, only to throw that bubbly poison into the woods. A lot of these friendships will not withstand the test of time—it's easy to lose touch or commonality when you're on such different paths. But the ones who stick around know your past and present, and that's pretty cool.

THE COLLEGE FRIEND

They saw you through breakups, all-nighters, and many weird hairstyles. Sometimes you realize they were friends out of convenience, sometimes they become surrogate siblings.

THE FAIR-WEATHER FRIEND

They want to be invited to your housewarming, but don't expect to hear from them when your dad is sick. These are the friends who require boundaries. You can't expect them to be who they are not.

THE RELATIONSHIP FRIEND

As soon as your partner introduced you, you became fast friends. You divulged relationship gripes, took them to your parents' beach house, and whispered to each other at parties. You thought it'd last forever—until your breakup...

THE WORK FRIEND

Thank God for them—how could you get through your boss's tantrums without their validating eye contact and post-meeting Slack messages? They might be the only person in your life who will show you how to back up your e-mails in exchange for a bagel at lunch.

THE PET FRIEND

They'll love you forever.

THE MARRIED FRIEND

You have the same taste in cheese shops and scented candles. It never feels like you see enough of them because of dogs and kids and spouses.

THE TOXIC FRIEND

You celebrate their successes, but they never seem to care about yours. They judge your new love interest and never return your texts—beware.

THE BEST FRIEND

They shamelessly dig up any information they can on your potential suitors, and they ask what you're wearing to the party on Friday. You've eaten fries in bed together, and they stayed for the entirety of your five-hour karaoke party. Different people may fill this role throughout your life, but the feeling will always be thrilling.

GETTING A PET BFF!

the best decision you'll ever make

- Strongly consider rescuing. There are many abandoned animals in shelters across the country. If your heart is set on a particular breed, you might research puppy mill rescues.

- Start planning for all of the expenses that come along with a pet. Get pet insurance ASAP if you've decided to go that route.

- Volunteer to watch a friend's dog or cat for the weekend. Fostering is always an option—just prepare to fall in love.

- Seek out adoption events. Most local pet stores will host or advertise these.

- Be sure you have the time! Aside from feedings, cleanings, walks, and vet visits, you also have to prioritize play time and cuddling.

- Animals are a huge responsibility. They are trusting you with their lives and will love you unconditionally, so be sure you aren't just ready, but that you are obsessed with the idea.

WHEN I CLOSE MY EYES I SEE YOU.

WHEN I CLOSE MY EYES I SEE YOU.

HOW TO KNOW IF
YOU'VE MET YOUR MATCH

(for right now)

- Do they ask you questions about <u>you</u>?

- Do they send you selfies/memes/dog pics?

- Do they know your favorite gummy candy?

- Do they treat your pet as well as they treat you?

- Do they agree that read receipts are awful?

- Do they prefer going for a walk and splitting a pizza over late-night debauchery (or are they open to late-night debauchery if that's what you're feeling)?

- Do they notice if you're sad?

- Do you want to turn to them and tell them everything?

- Do you trust them to hold your coat?

- Do you think about them and know they're thinking about you?

- Do you want to know everything about them right now?

- Do you always want to make them laugh?

HOW TO DATE IN THE

SPECIFY WHAT YOU'RE LOOKING FOR IN YOUR PROFILE, BUT EXPECT MOST EVERYONE TO GLOSS OVER IT.

JORDAN | BROOKLYN

LOOKING FOR SOMETHING SERIOUS. LET'S EAT TACOS, GO TO THE MOVIES, AND MAKE OUT IN FRONT OF MY APARTMENT BUILDING.

Ⓧ ✳ ♡

YEAH SO THAT'S PRETTY MUCH EVERYTHING I'VE DONE FOR THE PAST TEN YEARS

WOW YOU ARE SOO FASCINATING!!!!

DO NOT SPEND MORE THAN A WEEK TALKING TO SOMEONE FROM THE APPS. MEET UP BEFORE YOU FEEL LIKE YOU "KNOW THEM," BECAUSE YOU DON'T.

TREAT A FIRST DATE AS A LOW STAKES MEETUP. YOU MIGHT FEEL LESS ANXIOUS, YOU'LL BECOME LESS INVESTED, AND YOU WON'T FEEL GUILTY IF YOU HAVE TO CUT IT SHORT.

AGE OF THE APPS

KNOW THAT EVERYONE GETS GHOSTED. IT'S NOT ABOUT YOU AND IT'S TOTALLY HURTFUL.

GARY

AGE: 35
LOCATION: NY
SCHOOL: NYU

RELATIONSHIP: MARRIED

PLEASE DO YOUR RESEARCH !!!!!!!

SAY WHAT YOU MEAN, ASK FOR WHAT YOU WANT, BUT REALIZE IT WON'T ALWAYS GO YOUR WAY.

the art of kissing

EVERYONE WANTS THEIR MAKEOUTS TO REFLECT THE OPENING SCENE OF *ALL THE REAL GIRLS.* INSTEAD, THIS IS WHAT YOU GET:

THE TONGUE THRUSTER

THE PERSON WHO HAS MAYBE NEVER OPEN-MOUTH KISSED IN THEIR LIFE, AND THEY ARE NOT GOING TO START WITH YOU!!!

THE OPEN-REAL-WIDE-AND-DO-NOTHING KISSER

THE OVEREAGER KISSER

THE NO-CHEMISTRY KISSER

THE ONE-MILLION FACE-KISSES KISSER

THE SLOPPY KISSER

THE LIP LICKER

THE UNDENIABLY GOOD KISSER
(ONLY ONE FOR EVERY FIFTEEN PEOPLE YOU KISS)

THE PERSON YOU INTRODUCED TO LISTERINE STRIPS

?
THE LONG-TERM PARTNER WHO SWORE YOU TOLD THEM YOU DON'T LIKE MAKING OUT

THE MOANER

THE YOU-LIKE-THEM-SO-MUCH-WHO-CARES-HOW-THEY-KISS KISSER

THE FLIRTY KISSER

THE LIP BITER

THE DRUNK KISSER

THEY-CAN'T-KEEP-THEIR-LIPS-OFF-YOU-IN-PUBLIC KISSER

THE BARELY-
THERE KISSER

THE YOU'RE-COUNTING-
THE-MINUTES-UNTIL-
IT'S-OVER KISSER

THE TIGHT-LIPPED-
MORNING-BREATH
KISSER

THE HICKEY KISSER

THE SANDPAPER-
TONGUE KISSER

THE DEHYDRATED
KISSER

THE ROM-COM
KISSER

THE UNCOORDINATED
KISSER

THE EAR KISSER
(PS I LIKE THESE!!!)

THE FIRST-
KISS KISSER

THE EYES-OPEN-
WIDE KISSER

THE WANDERING-
TONGUE KISSER

THE TOOTHY
KISSER

THE SUFFOCATING
KISSER

THE LIPSTICK
KISSER

HOW TO NOT
IN A

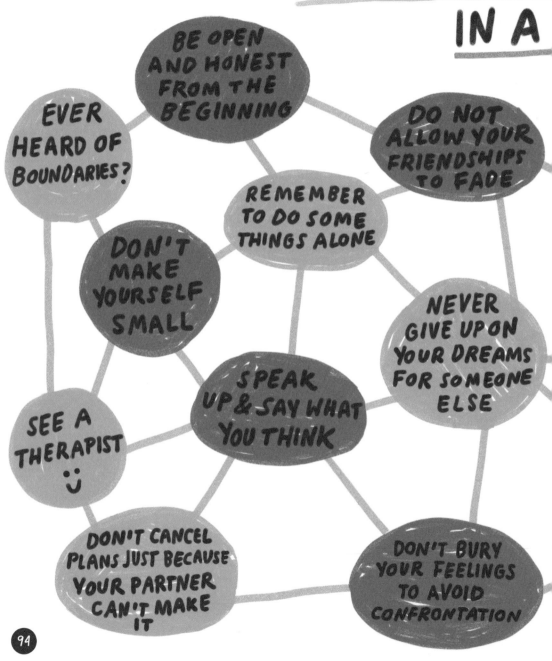

BE OPEN AND HONEST FROM THE BEGINNING

EVER HEARD OF BOUNDARIES?

DO NOT ALLOW YOUR FRIENDSHIPS TO FADE

REMEMBER TO DO SOME THINGS ALONE

DON'T MAKE YOURSELF SMALL

NEVER GIVE UP ON YOUR DREAMS FOR SOMEONE ELSE

SEE A THERAPIST :)

SPEAK UP & SAY WHAT YOU THINK

DON'T CANCEL PLANS JUST BECAUSE YOUR PARTNER CAN'T MAKE IT

DON'T BURY YOUR FEELINGS TO AVOID CONFRONTATION

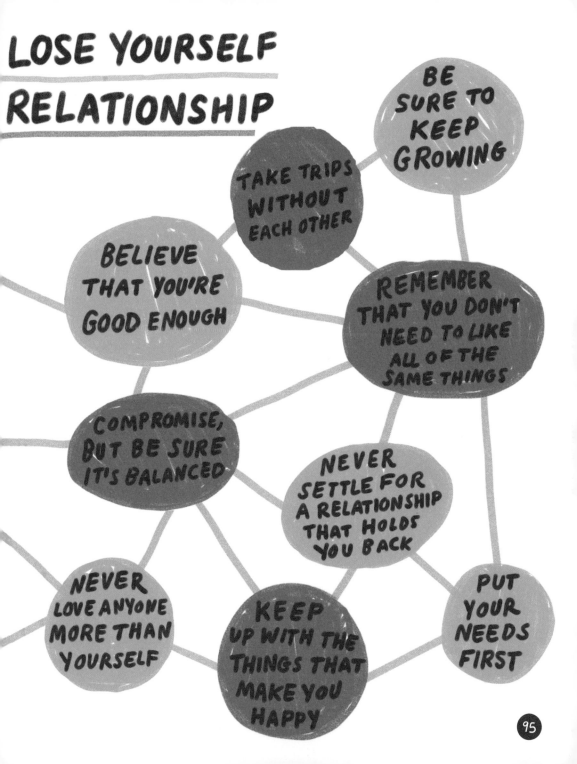

RED FLAGS

They come on really strong and intense at the start.

You feel like you wouldn't be seeing each other if it weren't for all of your effort.

They don't ask you any questions.

You're never introduced to their friends.

They're "TOO BUSY" for you.

You are constantly being canceled on.

They lie (even if it's small).

They speak poorly of an ex (especially off the bat).

You're always questioning their emotional investment.

You feel that you're always bending to their whims.

All of your friends dislike them.

They make you question how fantastic you truly are.

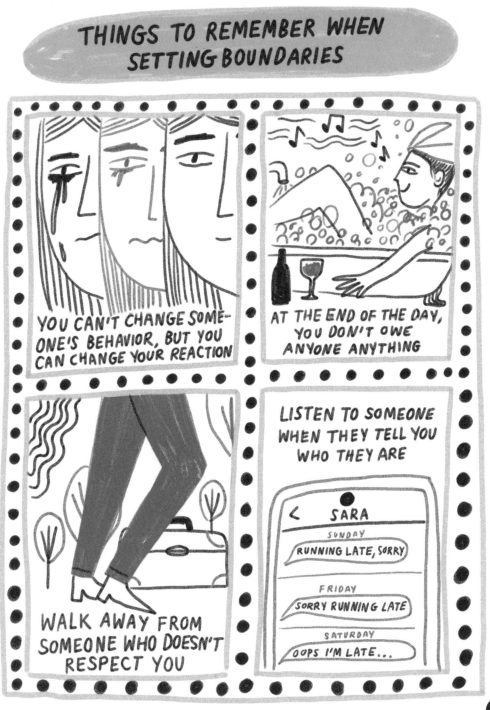

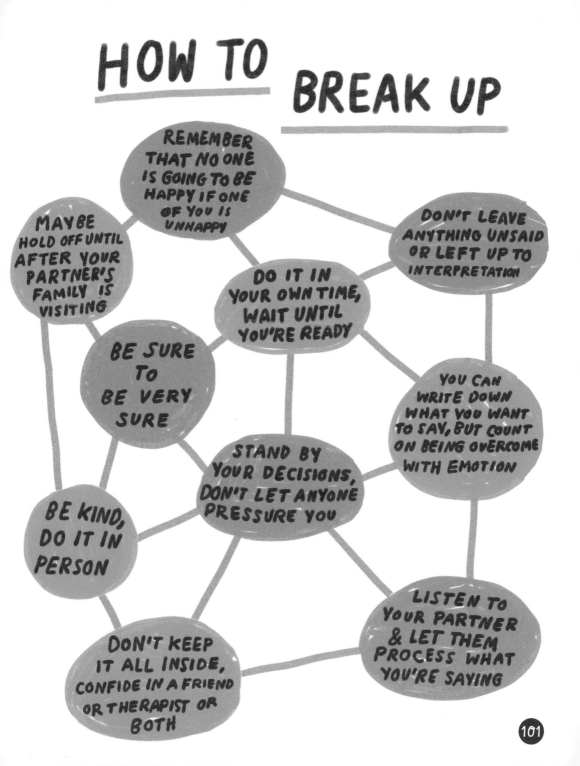

WHEN I SAY I DON'T CARE

WHAT I REALLY MEAN IS THAT I ABSOLUTELY DO AND WILL NOT IN 7 TO 10 DAYS AFTER I OBSESS AND OBSESS AND DISTRACT AND EVENTUALLY FORGET WHY IT BOTHERED ME SO MUCH.

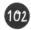

HOW TO RECOVER FROM A BREAKUP

1-3 DATE BLOW-OFF

- Line up 1 to 2 dates for the following week.
- Go for a run.
- Stalk their Instagram and decide they aren't that cute anyway.
- Remember all the weird or alarming things about them that you tried to suppress in the spirit of "keeping an open mind."
- French fries.

2-MONTH BREAKUP

- Listen to "Linger" by The Cranberries 17 times.
- Get your friends to stalk them on social media for you.
- Confess all to mom.
- Download every dating app.
- Talk on the phone for 42 minutes with a friend who will indulge you and remind you of your worth.
- Pizza.

6-YEAR BREAKUP

- Cry to the point of dehydration.
- Make a sad-yet-hopeful playlist that you loop for several hours a day over the course of weeks.
- Book a very impulsive and life-affirming vacation.
- Befriend every kind stranger who keeps tabs on you and provides encouragement over social media.
- Rescue a dog and name her after your favorite reality star.
- Join a kickboxing gym (and don't forget to cancel that membership a month later).
- Get a haircut and then befriend your stylist.
- Remember you'll be okay even though you're in agony.
- Gummy candy.

CAN YOU BE FRIENDS WITH AN EX?

I'D BE LYING TO MYSELF if I tried to give you a definitive answer, but what I do know is that breakups call for time and space, and that can look different for everyone. There are so many different variables—your past, residual feelings, new partners, growth, revelations—you never know what the future will hold.

Although the thought of having no relationship with someone you woke up next to every day for years is heart-wrenching (sometimes it's enough to keep two people together who are miserable), you deserve to be happy right now, regardless of who will stick around for it. Take it on a case-by-case basis.

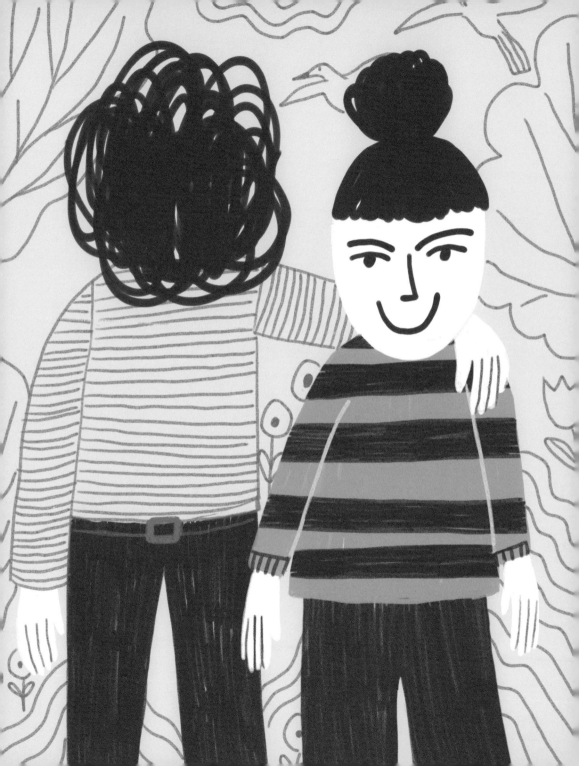

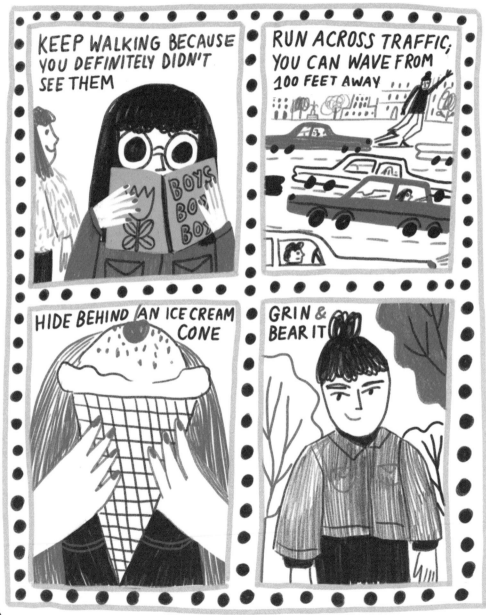

CHAPTER 4

LIVING MY BEST AND MOST EXCITING LIFE

SELF-CARE IS SELF-PRESERVATION: It provides us with the balance and awareness we need to keep running toward our dreams. You're in control of your own destiny—don't you forget it. Once you've taken the time to cultivate a hot and heavy relationship with yourself, you're ready to get out there, make things happen, and tackle whatever comes your way.

MAKING PEACE
WITH THE PAST

IT'S TRICKY TO ACCEPT that what was once a positive force in your life can come and go like anything else. During times like these, it helps to really think about how much you've grown—mentally and physically. The idea of willingly throwing yourself into something that you know will end someday almost seems certifiable. But when you're willing to make peace with this fact, you'll know you're headed in the right direction on your journey of self-acceptance. Anytime I'm feeling disappointed because a seemingly perfect thing or person exits my life, I try to think back to a similar situation from my past and realize that, oh yeah, I'm still here. Chapters finish, loose ends may never come together, but we've got to keep moving forward if we want to see what's waiting just ahead.

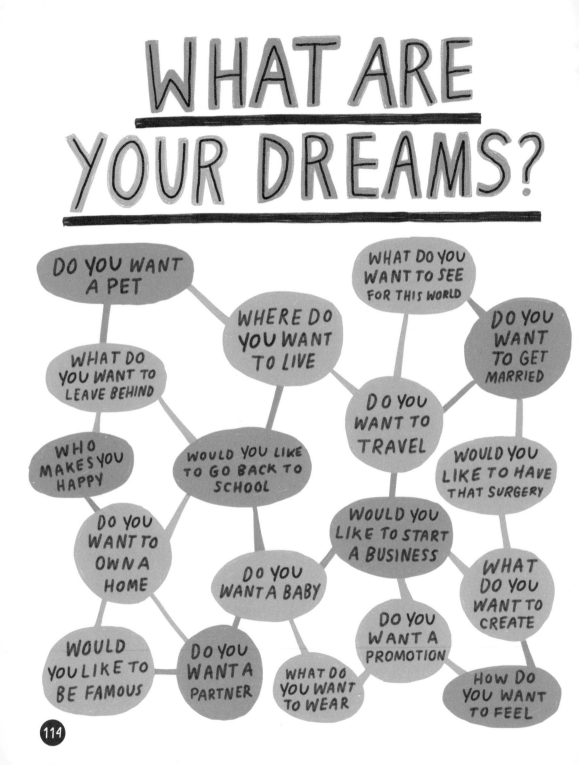

WHAT ARE YOUR DREAMS?

DO YOU WANT A PET

WHAT DO YOU WANT TO LEAVE BEHIND

WHERE DO YOU WANT TO LIVE

WHAT DO YOU WANT TO SEE FOR THIS WORLD

DO YOU WANT TO GET MARRIED

WHO MAKES YOU HAPPY

WOULD YOU LIKE TO GO BACK TO SCHOOL

DO YOU WANT TO TRAVEL

WOULD YOU LIKE TO HAVE THAT SURGERY

DO YOU WANT TO OWN A HOME

WOULD YOU LIKE TO START A BUSINESS

DO YOU WANT A BABY

WHAT DO YOU WANT TO CREATE

WOULD YOU LIKE TO BE FAMOUS

DO YOU WANT A PARTNER

WHAT DO YOU WANT TO WEAR

DO YOU WANT A PROMOTION

HOW DO YOU WANT TO FEEL

FINDING SOMETHING TO BELIEVE IN

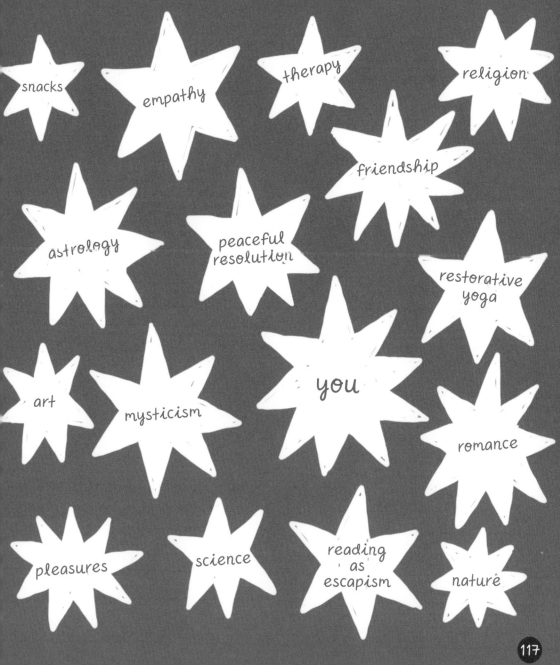

snacks

empathy

therapy

religion

friendship

astrology

peaceful resolution

restorative yoga

art

mysticism

you

romance

pleasures

science

reading as escapism

nature

DOING THINGS ALONE

We never know how many tomorrows we have,
so don't sleep on your dreams.

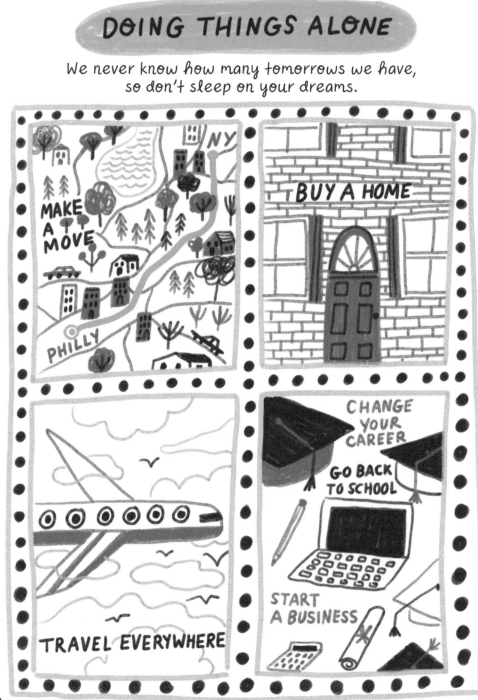

ESSENTIALLY **THIS JUST MEANS** PRACTICE MAKES PERFECT.

TO DO:
- ~~groceries~~
- ~~practice self-confidence~~
- walk the dog

THIS ONE TIME AT A PARTY...

IF YOU WISH YOU WERE A SOCIAL BUTTERFLY, TRY TO MIMIC SOME OF THE BEHAVIORS THAT YOU ADMIRE.

PUSH YOURSELF OUT OF YOUR COMFORT ZONE. THAT'S HOW YOU'LL BEGIN TO BUILD YOUR CONFIDENCE.

YOU'RE MAKING IT

TAKE A CHANCE.
YOU CAN ALWAYS
TRY SOMETHING
ON AND DECIDE
IT'S NOT FOR YOU.

ALWAYS BE TRUE TO
YOURSELF. BUT DON'T
OVERCOMMIT YOURSELF
OR LIE—THAT WON'T
HELP ANYONE.

THE POINT IS NOT
TO FOOL OTHERS,
IT'S TO TRICK YOUR
BRAIN INTO REMEM-
BERING HOW CONFIDENT
YOU REALLY CAN BE.

HOW TO KNOW IF YOU'RE DOING THE RIGHT THING

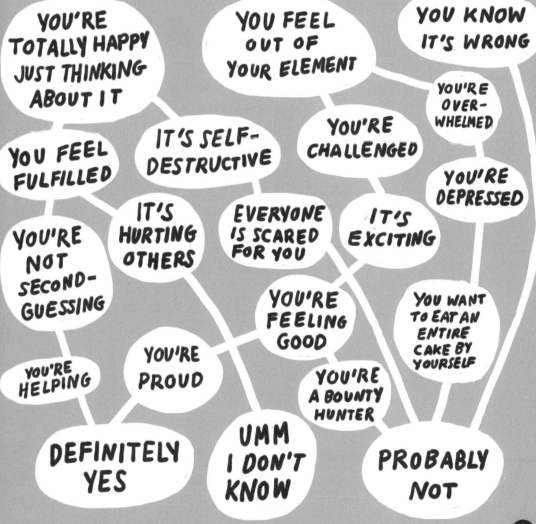

you always Know

TRUST YOUR GUT. You know when you're seeking advice from a friend and don't quite feel like you're painting the whole picture? That's because only you really understand your unique situation, your past experiences, and your own needs. The way your body's feeling, what thoughts are swirling around in your head—these are all signals that you're sending to yourself. Sometimes we're crowdsourcing thoughts from others because we're trying to run from our own truth.

If you're analytical, write your gut reactions down somewhere. If that's too much, simply sit with your thoughts. We love to Google and Yelp and Tweet for help, but often this is just getting in the way of what we already know and are too afraid to say. It's alright, it will be okay.

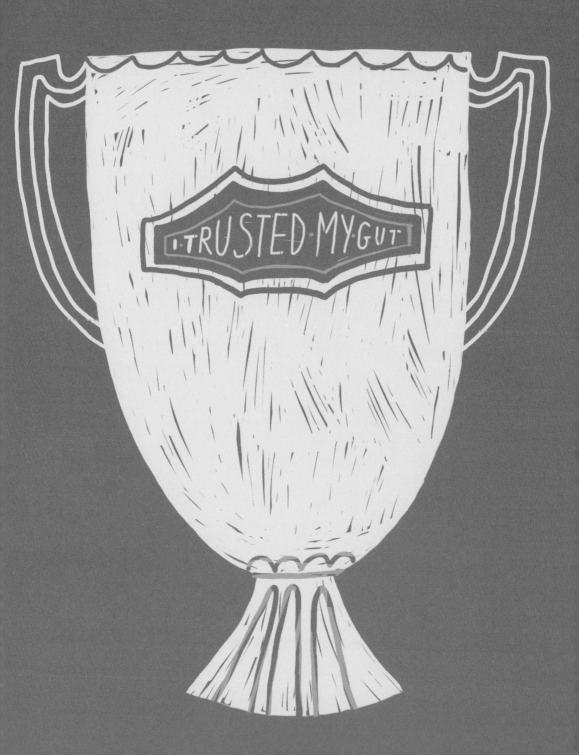

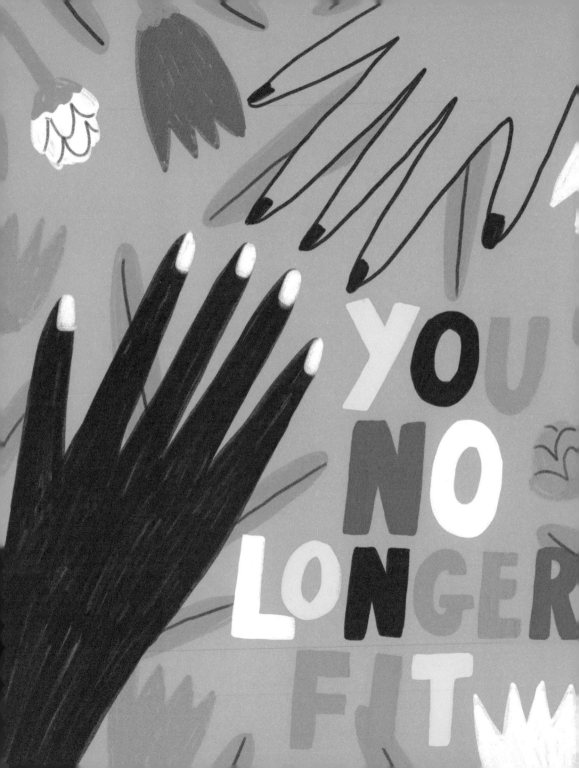

YOU
NO
LONGER
FIT

LEARNING TO

SAY NO

IF YOU DON'T WANT
TO DO SOMETHING,
SAY NO UPFRONT;
OTHERWISE IT WILL
EAT AT YOU

YOU CAN'T TAKE
CARE OF OTHERS'
NEEDS OVER YOUR OWN

ONLY YOU KNOW
WHEN YOU'VE OUT-
GROWN SOMETHING

SAYING NO WILL
REMIND YOU THAT
YOU'RE IN CONTROL
OF YOUR OWN DESTINY

RECOMMEND
ANOTHER PERSON
OR ANOTHER TIME

SAYING NO TO THE
THINGS THAT DON'T
FEEL RIGHT LEAVES
ROOM FOR THE
GOOD STUFF

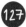

I GET BY WITH HELP FROM

MY FRIENDS PIZZA SEX PUPPIES
KICKBOXING TULIPS BRISK WALKS
WINE KISSING STRANGERS BERRIES
STICKERS NEW SHOES ANTIQUING
RUNNING DRAWING YOGA NAPPING
CHIPS TALKING TO MOM CLEANING
FACE MASKS DISCO MUSIC MEDITATION
JOURNALING TEA BATHS TELEVISION
COMEDY ROLLER SKATING THERAPY
PODCASTS COOKING ART PLAYLISTS
MOVIES THE BEACH REGULAR SLEEP
CRYING SELF-COMPASSION NATURE
TAKE-OUT DATING LYING IN A PARK
ASKING FOR HELP DANCING MEDICATION

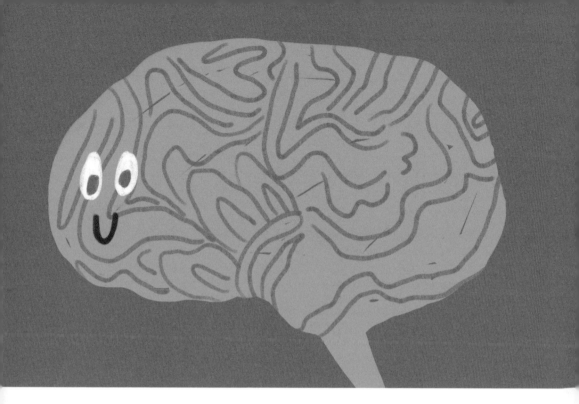

setting intentions

- Think of "setting intentions" as focusing.

- Decide how you want to feel, and then narrow down your decisions until you land on those that can put you on that path. For instance, if you're itching to be in a relationship, one-night stands might knock you off your course.

- Take emotions out of the equation. Draw a line in the sand if you need to; it's less about the other person and more about what you need.

- Never lose sight of your end goal.

FORMING A HABIT

Kick off habit building in a small way. Be present and incrementally increase the time you put in.

Start by rewarding yourself every time you commit to your habit. As time goes on, you won't need it.

It will be easier to form a habit if it's something that contributes to your happiness.

Build relationships with people who can help support you in your new practices.

Learn from your missteps. If you stray from your path, don't be afraid to just jump right back in.

THRIFT IF YOU HAVE $$$ DREAMS ON A $ BUDGET

STICKING TO A BUDGET CAN BE VERY ILLUMINATING

YOU DESERVE TO BUY THINGS THAT TRULY MAKE YOU HAPPY

PRIORITIZE YOUR HEALTH

PAY OFF YOUR BILLS WHEN YOU CAN, MAKE A PLAN WHEN YOU CAN'T

IF YOU CAN'T STOP THINKING ABOUT THE SHOES, BUY THE SHOES

SAVE FOR YOUR DREAMS

PAY FOR THINGS THAT WILL SAVE YOU TIME

DON'T BUY A SHIRT JUST BECAUSE IT'S ON SALE

SPENDING MONEY ON OTHER PEOPLE CAN MAKE YOU VERY HAPPY

SPEND MONEY THAT MATTER

DO NOT TRY TO KEEP UP WITH OTHERS

PRIORITIZE EXPERIENCES

SPEND ON THINGS THAT INSPIRE

PUT MONEY TOWARD YOUR COMFORT & SAFETY

INVEST IN YOURSELF

RECOGNIZE THAT YOU CAN'T HAVE IT ALL

TREAT YOURSELF FROM TIME TO TIME

LET'S PAY ATTENTION TO THAT DEBT

BE CHARI-TABLE

HOW TO
GO OUT AND
HAVE FUN

PUT THE PLAN
IN YOUR CALENDAR
SO YOU CAN LOOK
FORWARD TO IT

TRY TO LEAVE ALL
WORRIES AND STRESS AT
HOME—IT'LL STILL BE
RIGHT WHERE YOU LEFT IT

LET YOUR
HAIR DOWN

TALK TO
NEW FOLKS

FIND A FOGGY
ROOM TO DANCE
YOUR WAY THROUGH

NO ONE'S FREE?
SEE A MOVIE, EAT
AT A BAR, GET A
LATE-NIGHT MANI

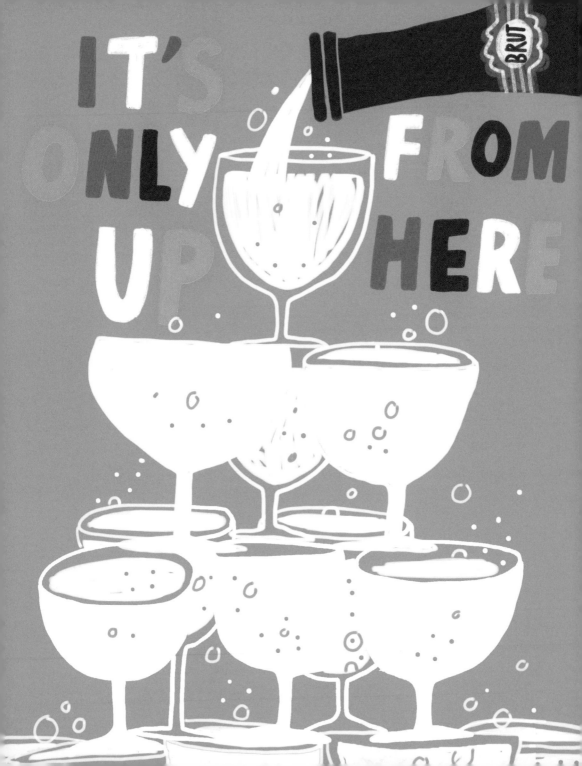

Everyone struggles. Everyone thinks about giving up. Ride it out until the tides change, or find a way to adapt.

Networking is invaluable, especially when considering a career move. Invite someone you admire out for coffee.

Sometimes, you might lose people as you find yourself. That's as normal as it is disappointing.

Feeling like you don't exactly fit a mold? You might just be an innovator! You've got to carve out your own space in the world.

What brings you joy? Do you see a way to monetize this?

CREATING A SPACE THAT YOU FIT INTO

Find any kind of stability in your life; it can be a great foundation to support you while realizing your dreams.

Cultivate a group of friends and peers in similarly transitional places in life. It's important to have cheerleaders and to cheer on others.

Not everyone will understand what you're doing. This doesn't mean you won't change minds along the way.

It's important to have role models. They inspire, challenge our way of thinking, and motivate us to keep going.

Even if it's really tough and terrifying, be vulnerable. You never know what can happen.

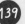